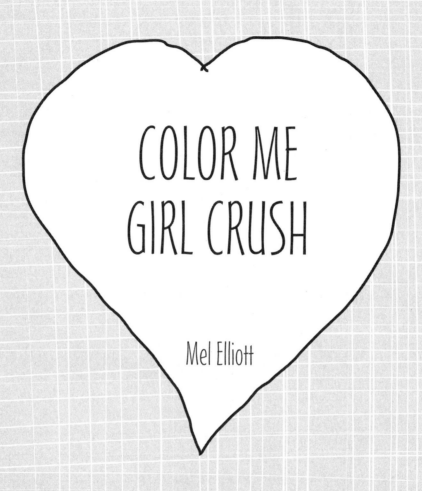

COLOR ME GIRL CRUSH

Mel Elliott

A PERIGEE BOOK

For my daughter Pearl, my mum Linda,
my grandma Doris, my sister Nanette,
and all the other wonderful women and
girls who have enhanced my life.

A PERIGEE BOOK
Published by the Penguin Group
Penguin Group (USA) LLC
375 Hudson Street, New York, New York 10014

USA • Canada • UK • Ireland • Australia • New Zealand • India • South Africa • China

penguin.com

A Penguin Random House Company

COLOR ME GIRL CRUSH

ISBN: 978-0-399-17128-4

First American edition: June 2014
Originally published in Great Britain by Portico Books in 2014.

PRINTED IN THE UNITED STATES OF AMERICA

10 9 8 7 6 5 4 3 2 1

While the author has made every effort to provide accurate telephone numbers, Internet addresses,
and other contact information at the time of publication, neither the publisher nor the author
assumes any responsibility for errors, or for changes that occur after publication.
Further, the publisher does not have any control over and does not assume
any responsibility for author or third-party websites or their content.

Most Perigee books are available at special quantity discounts for bulk purchases for sales
promotions, premiums, fund-raising, or educational use. Special books,
or book excerpts, can also be created to fit specific needs. For details,
write: Special.Markets@us.penguingroup.com.

COLOR ME
GIRL CRUSH

CONTENTS

MEL'S HALL OF FEMME

We once lived in an era where it was the norm for women to hate each other. We flicked through magazines raging with venomous jealousy and saying things like, "I don't know WHAT Luke Perry SEES in her! LOOK! She has a hair out of place, and oh my god, she is so FAKE!"

Luckily though, we woke up, realized that we are not in *Mean Girls,* and we now live in an age where women are allowed to like one another. We would rather appreciate other women *for* their flaws, rather than ridicule them.

That makes sense, right?

There may still be some pangs of jealousy. It's perfectly okay to "want her bottom" or appreciate someone's toned arms, wobbly tummy, or voluminous hair, but at the same time …

LET'S CELEBRATE FEMALE SOLIDARITY!

And what better way to celebrate than with a pack of markers!

So, markers at the ready, let's color in our favorite girl crushes, from the kooky, the funny, the stylish, the brainy, and the downright sexy.

Let's appreciate women of all shapes and sizes for their individuality, their bravery, their style, their hair, or their ability to entertain us while still being completely gorgeous.

You also get the chance to score each lovely lady out of ten. Don't be mean though, and concentrate on their good points. Adele's voluminous hair for example? A TEN! Taylor Swift's legs? A TEN! Beyonce's strong thighs? A MILLION SQUILLION!

Feel free to embrace the stylist in you too! Add patterns to dresses, bows to hair, and go crazy on the makeup. Most of all, have fun and color them good.

Love,

Mel

x

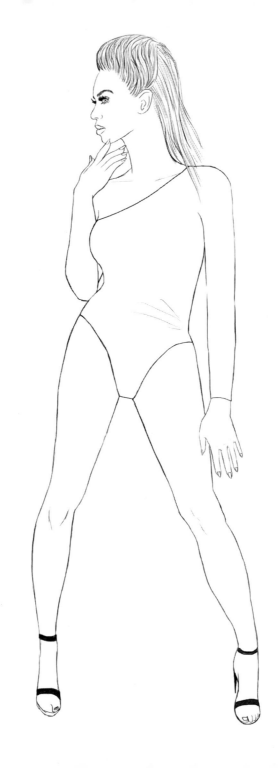

BEYONCÉ

Please let me be Beyoncé
I swear I'll work out every day
I'll worship Jesus and I'll pray
I'll learn to knit and crochet
I'll pull orphans around in the snow on a sleigh
I'll rehome any poor dogs that are stray
I'll learn to cook the perfect soufflé
And stop eating crap, greasy take-away
I'll find out the way to San José
and not eat sweets and get tooth decay
I'll do crafts with my kids like papier-mâché
and take them to swimming or tap or ballet
I will never lead anyone else astray
And all life's rules I will strictly obey
If I could just be Beyoncé
Like, just for a week, so what do you say?

You don't have to score Beyoncé out of ten, I did it for you

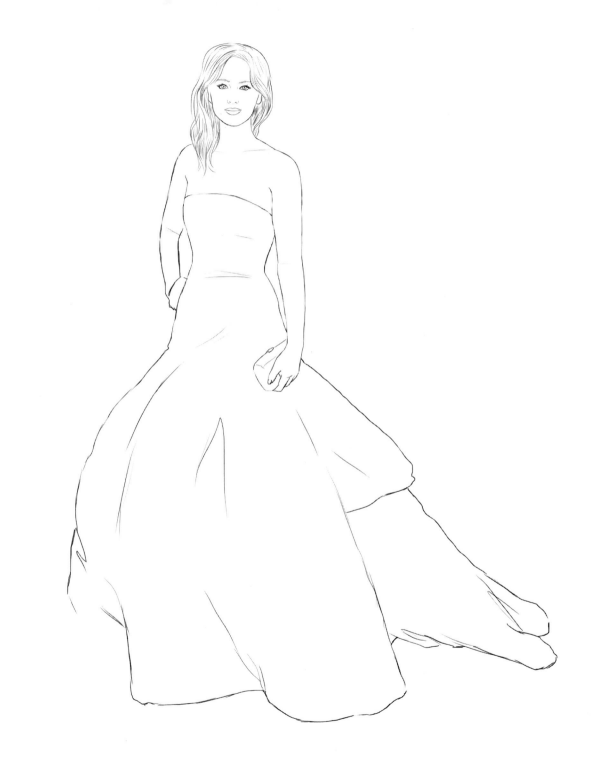

JENNIFER LAWRENCE

She may be the ultimate girl next door: quirky, sarcastic, and … clumsy in a huge dress. We love Jen for the way she seems so real compared to many stars. But the star factor shines through anyway: this is a girl who deliberately goes to big bashes with no makeup and still looks heart-stoppingly gorgeous.

Perhaps it shouldn't be a surprise: one of her best-known roles on screen has been a woman with no makeup, and usually in a mess from fighting for her life! In *The Hunger Games,* she is too busy being epic at shooting things with a bow and arrow to sit around feeling like a damsel in distress. In fact, that's the man's job in this film!

Hunger is apparently on Jennifer's mind as well: she champions eating properly and has no interest in starving herself for roles. Of the many quotes floating around the Internet, I think my favorite is the one where she says, "I eat like a caveman!" I think we should all go and get a slice of cake now in celebration of how awesome Jennifer Lawrence is. And then maybe take up archery lessons to burn off the calories.

Jennifer scores 10

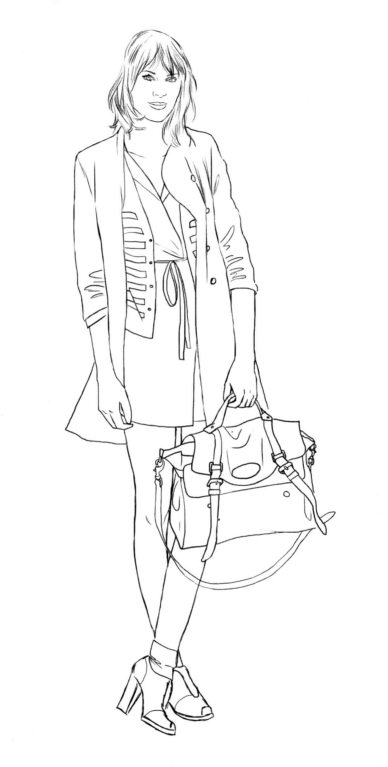

ALEXA CHUNG

Alexa is one of the coolest kids on the block and she hangs around with all the other cool kids to prove it. Her style is so understated and effortless that it's easy to believe she actually wakes up looking this cool. (Maybe she does! How depressing is that!?)

With "don't care" hair and minimal makeup, her style equates to grown-up schoolgirl + tomboy x Chanel.

Alexa is so cool that Mulberry even named a bag after her!

If Mulberry named a bag after YOU, what would it look like?

Alexa gets an effortless / 10

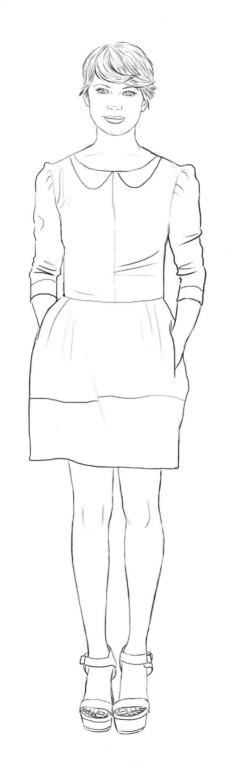

MICHELLE WILLIAMS

There are plenty of actresses in this book, but I think that Michelle Williams is one of the best. Her performance in *Blue Valentine* left me emotionally exhausted (and yes, I have forgiven her for kissing Ryan Gosling), and her portrayal of Marilyn Monroe in *My Week with Marilyn* made me completely forget I was watching Michelle Williams and not Norma Jean herself.

However, one of the BEST things about Michelle Williams is her hair. She has the best hair since Meg Ryan circa 1994. It was straight after drawing the image opposite that I went to my hairdresser and said I wanted hair like Michelle Williams. I left the salon looking less like Michelle Williams and more like Elliott from *E.T.*, but you can't have everything, and anyway, I used to think the kid in *E.T.* was really cute.

Michelle scores /10

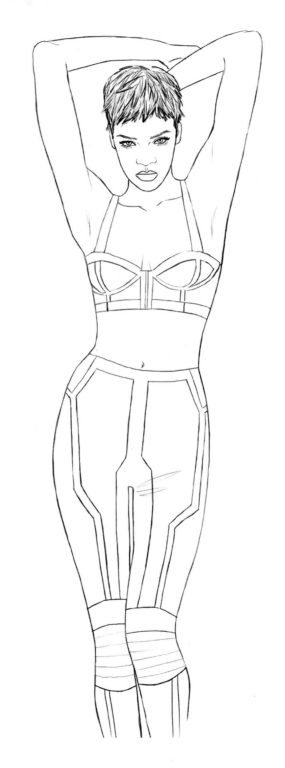

RIHANNA

She's the good girl that turned bad
With outfits that are rad
All men, they want to kiss her
Your brother, your uncle, your dad

But if they want to be her fella
They'll need an umbrella
and when she's on a high
She's like a diamond that is stellar

Her costumes are revealing
But her body's quite appealing
and her performances are mega
as she sings with passion and feeling

With a truly outrageous manner
Some stations want to ban her
But whatever she does or thinks or says
We love that girl Rihanna

Rihanna scores

10

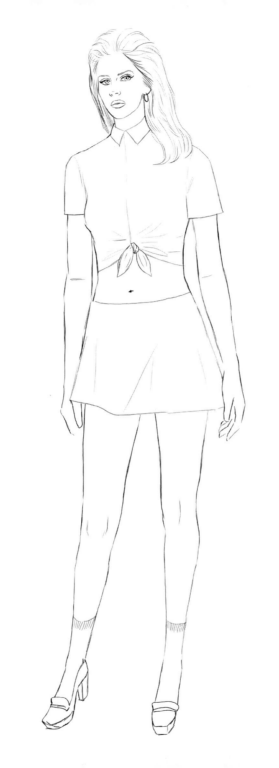

LANA DEL REY

If you had blanked out on all pop culture from the moment you were born, you may be forgiven for thinking Lana Del Ray was a singer from long ago: from her looks to the tweaking on her publicity shots and album covers, everything about her says "vintage" and "retro" and also "kind of scary." With her sometimes smoky voice and the sultry glower in her photos, she's making a big stand against any sort of "pop" labeling, even before you hear her music.

Though she's only stomped onto the music scene recently, her fantastic retro look—from vivid lipstick to huge bundles of flowers in her hair—has already captured peoples' imagination. And she's already had a Mulberry bag named after her.

I'd be lucky to have a bag of potato chips named after me!

Lana scores

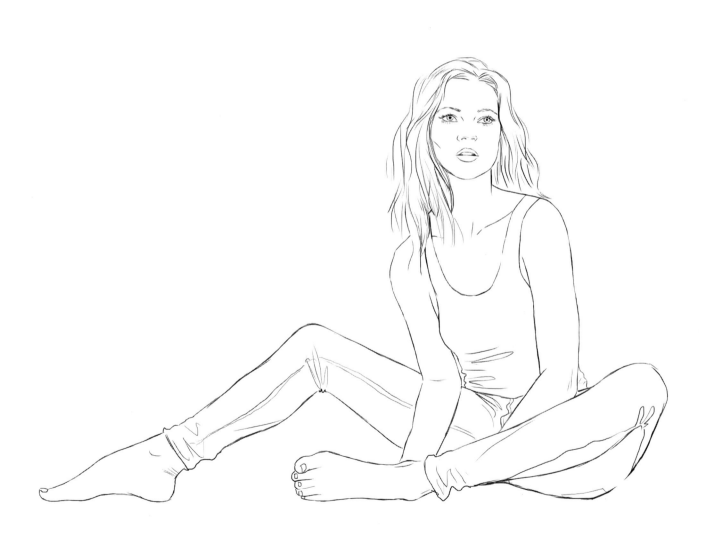

KATE MOSS

How awesome we all thought we looked in our boot-cut jeans, sashaying around like Monica from *Friends* and playing "snake" on our mobile phones. That was until Kate Moss showed up in some magazine wearing a pair of skinny jeans.

This was 2002 and over a decade later we're still mad for skinnies. If Kate Moss hadn't worn her gray Superfines all those years ago, would we still be walking around with cowboy legs? I dread to think!

Kate is the world's best-loved supermodel, and while we know we won't look as good as her in our skinnies, we want to give it a damned good try.

Kate scores a trendsetting

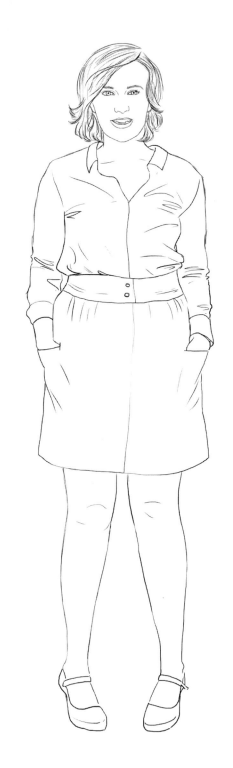

LENA DUNHAM

When I heard about *Girls*, I assumed it was going to be another *Sex and the City*, and as brilliant as *SATC* was, we've already done that. The fact that the characters in *Girls* are younger than me also had me assuming I wouldn't relate to it, and so when I sat down for the first episode, it had already failed for me.

But how wrong I was.

Lena Dunham's creation is so fresh, so real, and SO relatable that men and women of all ages lap it up.

The four lead characters represent an astounding observation of women, each one flawed to the brim but oozing charisma, and making us (and our problems) feel like we'd easily fit into their gang.

Hannah, played by Lena Dunham, has an awkward style with nothing fitting quite right, but whether she is wearing patterned blouses, short playsuits, or babydoll dresses, she always looks really cute.

I remember my mum always telling me not to use my pockets and that they were sewn up so that they wouldn't spoil the shape of the clothes. "So what's the point of them being there at all?" I would ask. Hannah uses her pockets ... and so do I— it saves money on handbags and mittens.

Lena scores

/10

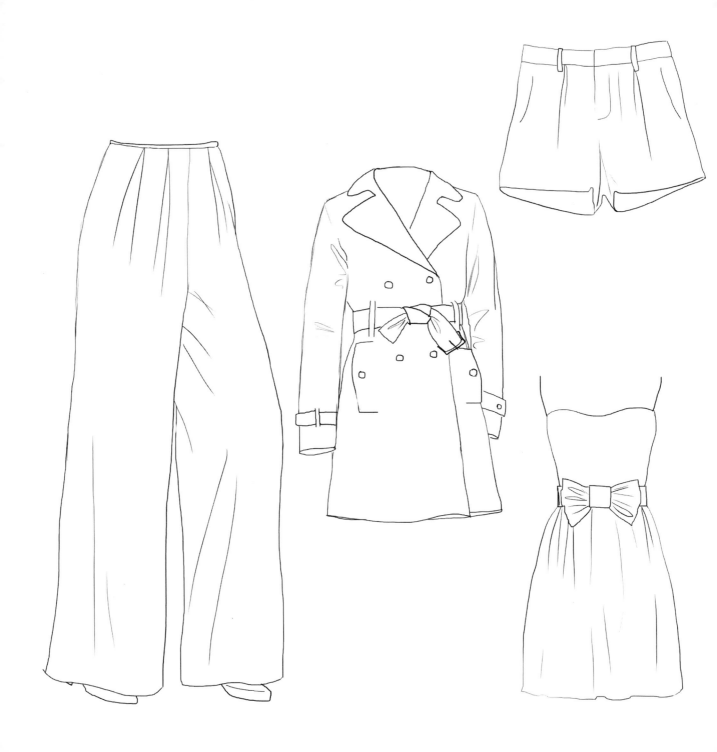

Zosia Mamet aka Shoshanna

Lena Dunham aka Hannah

Try to match the *Girls* characters to their item of clothing

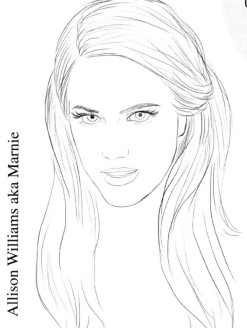

Allison Williams aka Marnie

Jemima Kirke aka Jessa

ROM-COM SPECIAL

From Lucille Ball and Doris Day to Kristen Wiig
and Emma Stone, some women are just great at
making us LOL and ROFL, while still looking
completely drop-dead gorgeous.

My rom-com special celebrates seven leading
ladies (Meg Ryan, Julia Roberts, Renée
Zellwegger, Mila Kunis, Sandra Bullock,
Reese Witherspoon, and Drew Barrymore), each
one having delighted us in the rom-com genre.

MEG RYAN

Sleepless in Seattle
You've Got Mail
When Harry Met Sally
French Kiss

/10

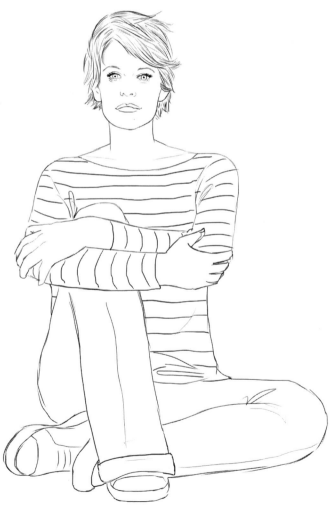

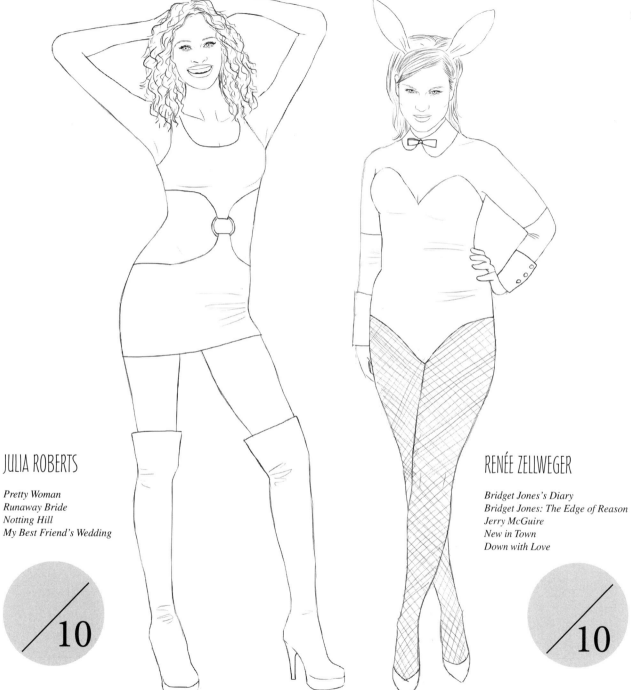

JULIA ROBERTS

Pretty Woman
Runaway Bride
Notting Hill
My Best Friend's Wedding

/10

RENÉE ZELLWEGER

Bridget Jones's Diary
Bridget Jones: The Edge of Reason
Jerry McGuire
New in Town
Down with Love

/10

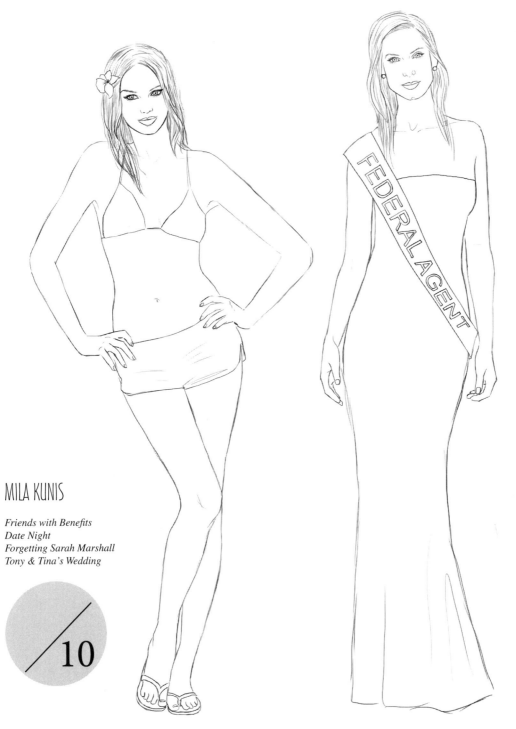

SANDRA BULLOCK

Miss Congeniality
Speed
While You Were Sleeping
The Proposal
Two Weeks Notice

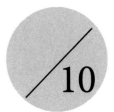

MILA KUNIS

Friends with Benefits
Date Night
Forgetting Sarah Marshall
Tony & Tina's Wedding

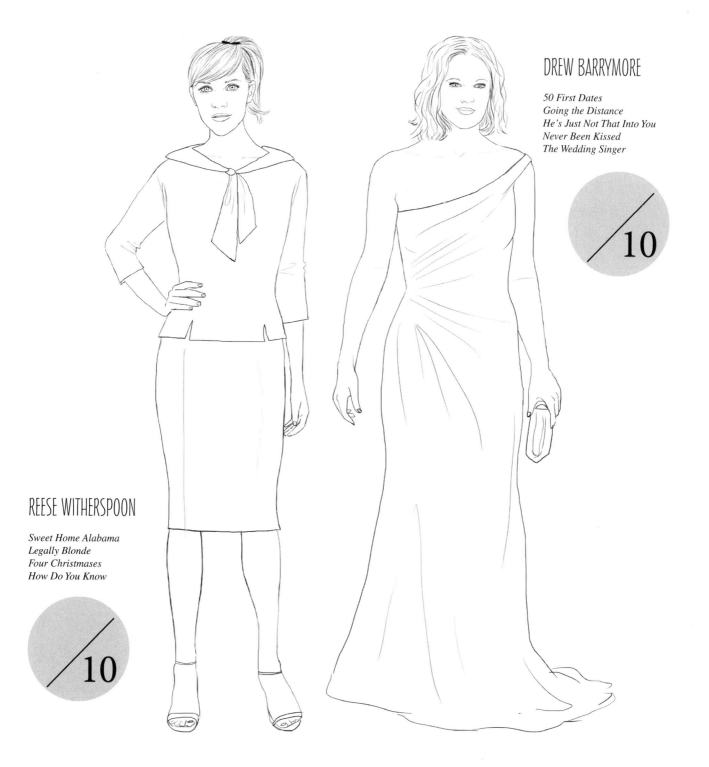

DREW BARRYMORE

50 First Dates
Going the Distance
He's Just Not That Into You
Never Been Kissed
The Wedding Singer

/10

REESE WITHERSPOON

Sweet Home Alabama
Legally Blonde
Four Christmases
How Do You Know

/10

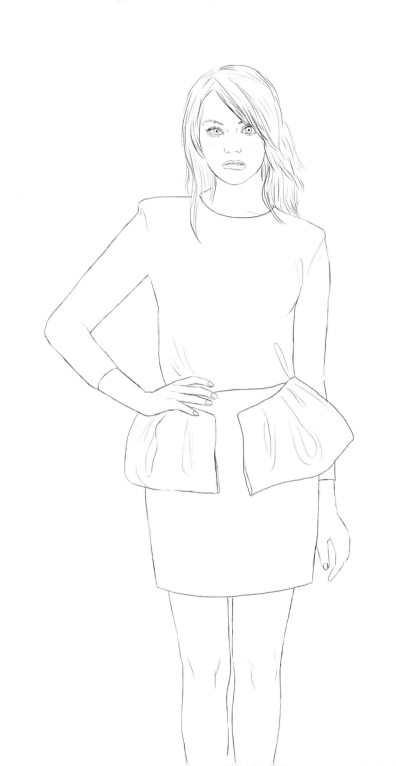

EMMA STONE

She's the girl next door with the freckles and the ginger hair. And the husky voice. Did I mention the husky voice? She has a vibe as she laughs and jokes through her interviews that just says she would be great to hang out and gossip with.

As one of the stars of the epic rom-com *Crazy, Stupid, Love*, we—well, I—fell in love with her as the awkward but gorgeous Hannah, who utters the immortal line to Ryan Gosling's character with something bordering on horror: "It's like you're Photoshopped!" I think that's still composed compared to how I might be in that situation!

Her style is casual, fun, and colorful and somehow she always looks flawless in whatever she wears. Her hair can be red, blonde, or brunette— and no matter the color, she pulls it off.

Emma scores a very cute /10

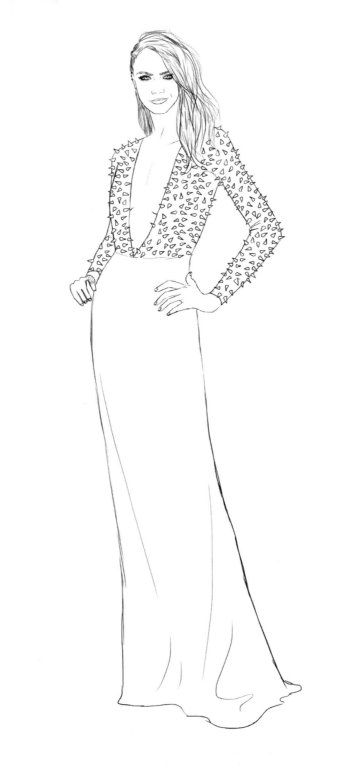

CARA DELEVINGNE

Cara Delevingne makes us all go green
With envy as we witness the best eyebrows we have seen!

She struts her stuff for Burberry, Gucci, Prada, and Preen
The front row sits in awe as she lowers their self-esteem

Her face is animated, she's every photographer's dream
Her pout is like a pillow, her smile like a laser beam

Magazines united, one thing they're all agreeing
CARA IS A MEGA-GORGEOUS SUPER HUMAN BEING!

Cara gets a mega-gorgeous

10

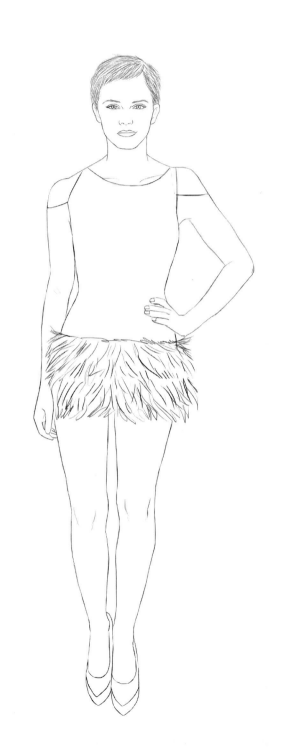

EMMA WATSON

After Emma Watson shed her Hermione skin and stepped out as a fey, leggy butterfly, I imagine most girls looked in the mirror and wondered if they'd look cute with a pixie haircut. Luckily, most of us sensibly put down the scissors.

Emma's got an eye for startling red-carpet style. When she strutted her stuff wearing a thin lace dress with a short skirt made of sleek black feathers resembling raven's wings, no one could have thought she was a child actor anymore. Very witchy and very mature! I'm not sure what charm she used to keep her legs warm when she was wearing it, but it made me think she might be magic after all.

I had a quick go at making up my own *Harry Potter* spell she might have used to become a stylish star: wave your wand and say "Stella Nitidus!"*

Emma gets

10

* Can't promise any magic will happen if you never got your Hogwarts letter.

CHRISTINA HENDRICKS

Mad Men's style is notable for many things, but one character particularly stands out: the curvaceous Joan, aka Christina Hendricks, in what has become her breakout role. With her striking red hair and perfect hourglass figure, it's hard to look at anyone else when she's on screen!

On the show, she wears a range of knee-length, colorful dresses, and suit skirts or tight pencil skirts with loose silk shirts, usually matched with a flawless updo. Perhaps the most interesting piece of TV jewelry is the long necklace Joan wears with a pen as a pendant. It's a fantastic piece and even has a practical use, a great symbol of a character who can get things done in her office! If you love the retro look, now is probably the time to sit down with a box set of this show …

Christina Hendricks gets a voluptuous

10

JULIANNE MOORE

In *A Single Man*, set in the swinging '60s, Julianne Moore plays the BFF of a delicious yet saddened gay man played by Colin Firth.

Okay, we've all done it. Had a few girly cocktails and then attempted makeup application before hitting the town—but most of us haven't done it with the style and panache Julianne Moore displays in this film.

With a gin in one hand, she applies perfect eyeliner and then sashays around swigging and mumbling and generally being just like I aim to be when my children leave home (and with all the same furniture to bump into too).

If I can look and be anything like Julianne Moore in this film one day, I'll be a very happy woman (well, happy in a "high on alcohol, glamorous cigarettes, and fabulous wardrobe" kind of way).

I give Julianne Moore

10

NATALIE PORTMAN

One of the more intellectual Hollywood stars of our times, and with an elegance and beauty that has drawn comparisons to Audrey Hepburn, this is one almost supernaturally perfect lady. The comparisons to Audrey have come all through her career: once she even got to pose in the actual dress from *Breakfast at Tiffany's*! Her photo shoots and red-carpet style are classic and timeless.

In one of my favorite films, *Closer*, Natalie plays the vulnerable Alice and completely holds her own against Jude Law and Julia Roberts.

A lifelong dancer, she put her flexibility literally to the test with the gothic ballet horror *Black Swan*. She has also happily proved that she is one of those women who looks good shaved bald and dressed in a sack, as seen in *V for Vendetta* … Now there's a hard look for the rest of us girls to pull off! Anyone planning to marathon watch this actress's back catalog should come armed with a cushion to hug and a mug of hot chocolate to steady the nerves.

Natalie scores a sophisticated /10

KRISTEN STEWART

Tousled-haired Kristen is well-known for her pouty, cool attitude and reluctance to smile on camera, perfect for her role as Bella in *Twilight*. While Bella wears a range of comfortable (and, importantly, warm, considering the icy hunk Edward she spends the film series sighing over) indie clothes, Kristen Stewart has an edgier look that is decidedly punky.

In real life, she often is seen wearing band T-shirts and has a history with punk rock: she played Joan Jett in *The Runaways*, a much wilder character than the one most people associate with her, but perhaps closer to Kristen's heart. She can play the guitar and sing, doing so for that film, and these days she sports a few punk tattoos. She looks a great deal more comfortable in the shots of her out and about in her normal garb than she does in her dresses for premieres and award ceremonies!

Kristen scores

/10

ANNA WINTOUR

Anna Wintour is the English editor in chief of American *Vogue*, as well as being art director of its publisher, Condé Nast.

However, she is best known for sitting in the front row at fashion shows, sporting dark glasses and a facial expression that gives nothing away. She is often seen surrounded by A-listers, all looking deeply terrified and desperate to be liked by her.

Anna scores /10

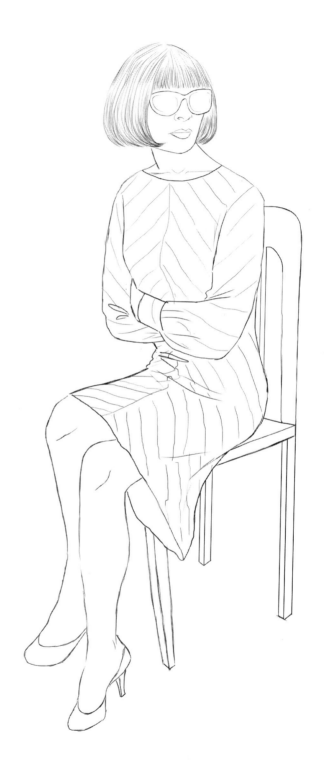

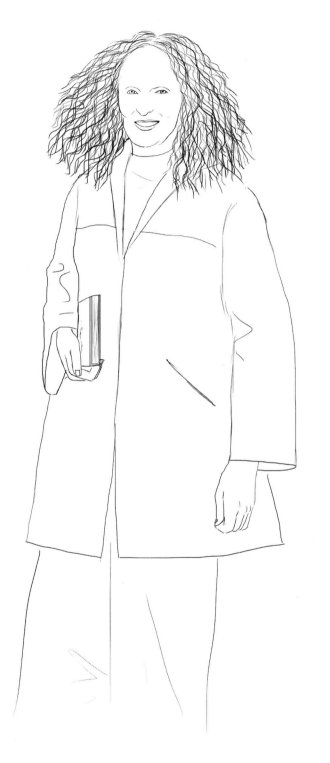

GRACE CODDINGTON

Often seen alongside Anna Wintour, Grace Coddington is American *Vogue*'s creative director.

The former model and crazy-haired beauty couldn't be more different from Anna, often sporting mannish coats and a big smile.

Grace scores
/10

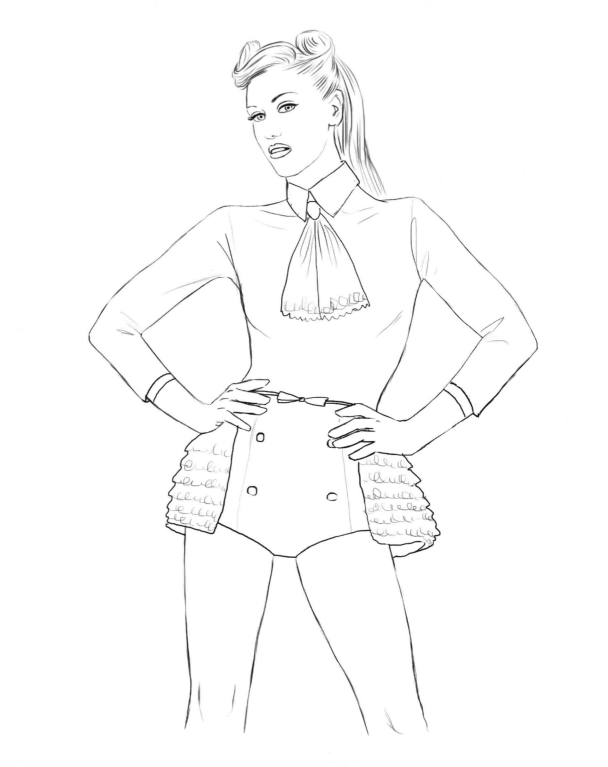

GWEN STEFANI

Picture the scene ... Gwen Stefani is sitting alone in a stinky dressing gown, sobbing because some guy said he'd call and he didn't, or because some dude dumped her beacuse she was too opinionated or something.

Difficult, isn't it? That's because Gwen Stefani is a TOUGH GIRL! She'd accept it, then go have some fun!

I remember hearing "Don't Speak" for the first time and thinking it was great. It was some days later that I managed to *see* Gwen and, like most people, totally ignored the rest of the band that was No Doubt.

WHAT A BABE! With her navy polka-dot dress (which she wore with no shoes OR socks) and her '50s glamour hairdo teamed with a punkesque vibe, it's no doubt that Gwen started the vintage/retro fashion revolution that is so big today. All of a sudden, vintage became less "twee" and more "twough"!

It wasn't too long before Gwen Stefani's style needed its own label, and so her fashion line L.A.M.B. was born.

Gwen gets 10

FAMILY SPECIAL

DAKOTA & ELLE FANNING

These adorable blonde actresses have been in showbiz for almost their whole lives. Elle has been appearing as young versions of Dakota's characters for their whole career, but now she's the taller one of the two!

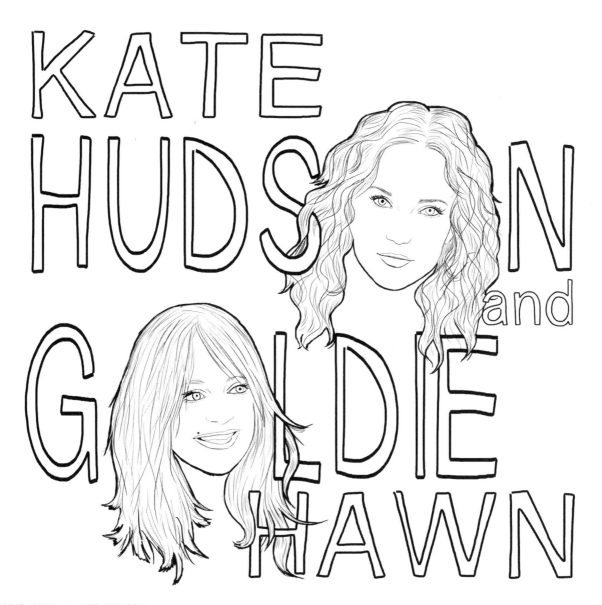

KATE HUDSON and GOLDIE HAWN

GOLDIE HAWN & KATE HUDSON

It must be hard having the cutest mom in the world, but Kate Hudson takes it all in stride. With their wavy blonde locks and cheeky grins, this duo are often seen out partying, shopping, and enjoying each other's company like moms and daughters should. It's not hard to see why they get along so well.

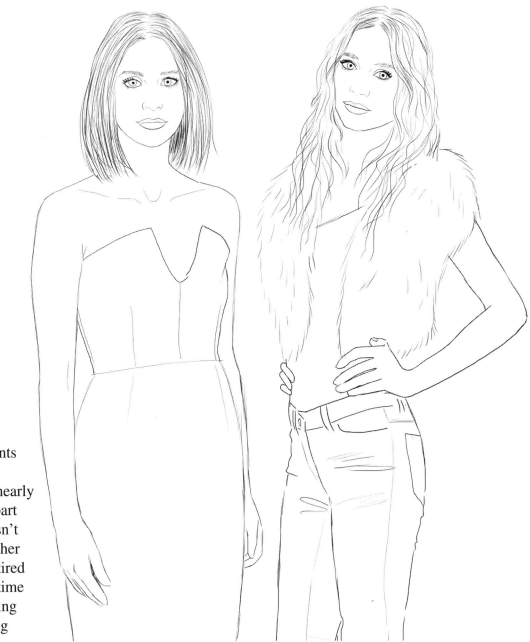

MARY-KATE &
ASHLEY OLSEN

Acting almost from birth (if being held while on screen counts as acting!), these superstar twins are nearly impossible to tell apart when one of them isn't dyeing her hair another color! They have retired from acting for the time being and are focusing their energy on being fashion designers.

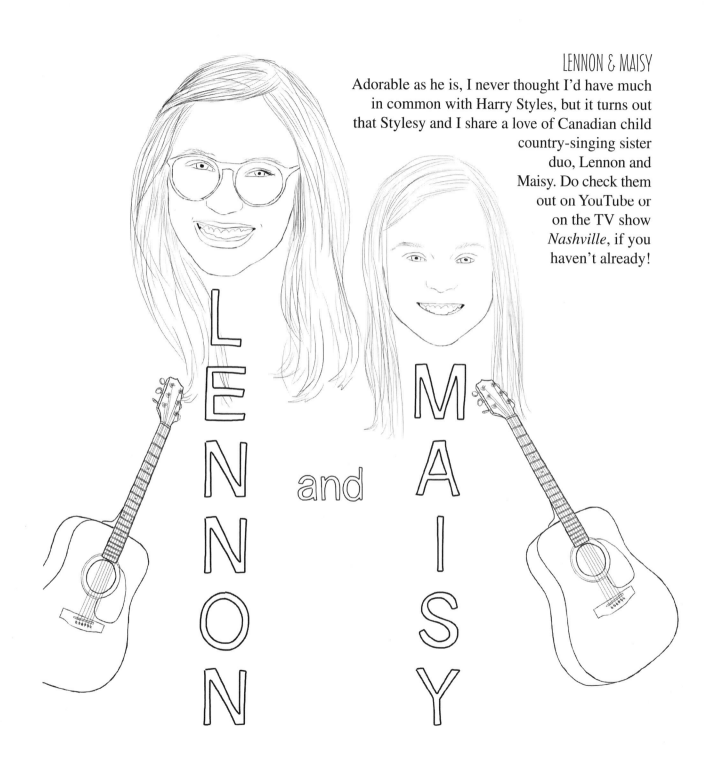

LENNON & MAISY

Adorable as he is, I never thought I'd have much in common with Harry Styles, but it turns out that Stylesy and I share a love of Canadian child country-singing sister duo, Lennon and Maisy. Do check them out on YouTube or on the TV show *Nashville*, if you haven't already!

LENNON and MAISY

AUDREY TAUTOU

Everyone named "Audrey" is adorable. FACT.

I love Audrey Tautou and have watched most of her films. The reason I love Audrey Tautou is that she is French. Which means that, more often than not, she is in French films, which means that, more often than not, they are subtitled ... and I LOVE subtitled films.

The reason that I love subtitled films is that (A) everyone else in my house hates subtitled films so I get to watch them alone, and (B) since my early 20s, due to a bone disease in my inner ears, I am partially deaf. Subtitled films let me, with the soundtrack faintly in the background, read the wonderful scripts, watch the wonderful expressions on the actors' faces, and enjoy the films utterly and completely (which is very difficult to do otherwise).

It's only when you watch films in this way that you truly appreciate facial expressions, subtle eye movements, and the way someone walks, smiles, or frowns. Audrey Tautou has an incredibly expressive face.

In *Amélie*, Audrey is totally adorable, but please try some of her "proper" French films.* Turn the sound down really low, and experience her true beauty like I do.

I give Audrey

* Try *Delicacy* and *Priceless* for starters.

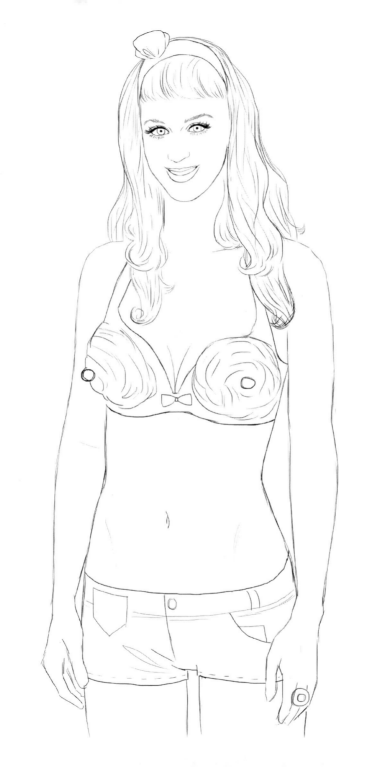

KATY PERRY

Whoever said "less is more" obviously forgot to send Katy Perry the memo. And, you know what? I'm glad Katy didn't get the memo.

Who doesn't want to run around all day wearing sequins and glitter and tiger suits and bras that look like giant cupcakes, and sing and shout and dance and ROAR!?

You don't? How about if you were five years old?

Being very good at something doesn't automatically mean that you have to take yourself and your profession too seriously— I should know!

Stay crazy, Katy!

Katy gets a roaring

10

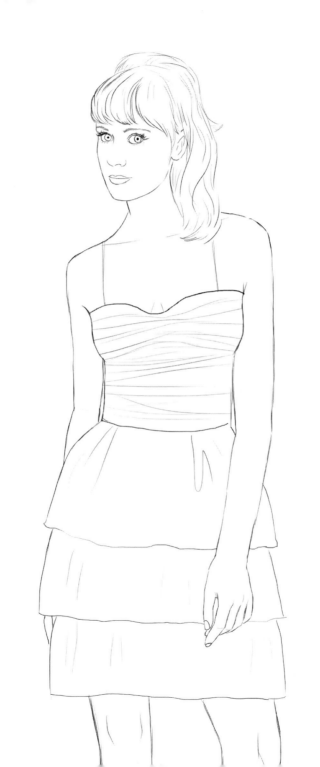

ZOOEY DESCHANEL

When I asked my Twitter and Facebook friends for their thoughts on who to put in *Color Me Girl Crush*, Zooey Deschanel's name popped up time after time.

Once labeled "the cutest girl in the world," Zooey Deschanel made quite an impression with her small role in *Almost Famous* in 2000. With her quirky style, she was a welcome change from the leggy blonde film stars we'd been used to. Zooey found mainstream fame as the "indie chic" girl—her role in *(500) Days of Summer* being the perfect platform.

Her hit TV show *New Girl* is in its third season and features Jess, a young woman who shares an apartment with three single men following a bad breakup. Zooey sings the theme tune, and in my opinion, Zooey's indie-folk band, She and Him, is responsible for one of the loveliest Christmas albums of all time.*

Zooey gets

* *A Very She and Him Christmas*, 2011.

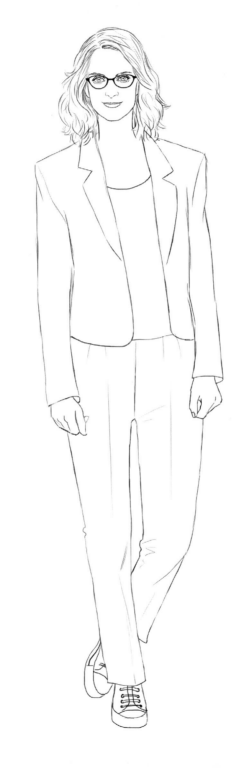

TINA FEY

Tina Fey is lovely to behold, hilarious to watch, and not afraid to lampoon the biggest names in the world. A *Saturday Night Live* regular, the videos of her impersonating Sarah Palin went viral, and audiences loved her impression so much that some of the quotes from her skit were mistakenly attributed to the real politician!

Her iconic character from *30 Rock*, Liz Lemon, is a fantastically awkward woman who isn't afraid to make a fool of herself, and Tina embraced the character, having a world of fun with her.

What would your alliterative fruit-based surname be?

...

I'd be Mel Melon.

I award Tina

10

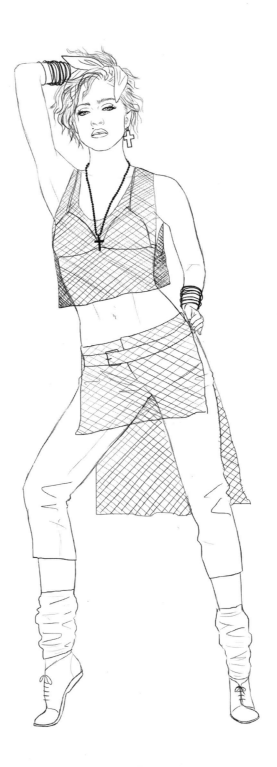

MADONNA

Madonna's 1983 self-titled album features some of the best pop songs ever.* But when it debuted, grown-ups everywhere were shocked and horrified at Madonna's scanty attire, believing that if you can see a woman's bra strap, she's basically naked.

Madonna didn't listen to the critics, and decades later, she continues to challenge audiences with her musical innovation and fashion bravery. Madonna is probably the most influential female pop star to date, with many of her contemporaries emulating her without even realizing it!

Madonna scores /10

* "Borderline," "Holiday," "Lucky Star," "Get Into the Groove."

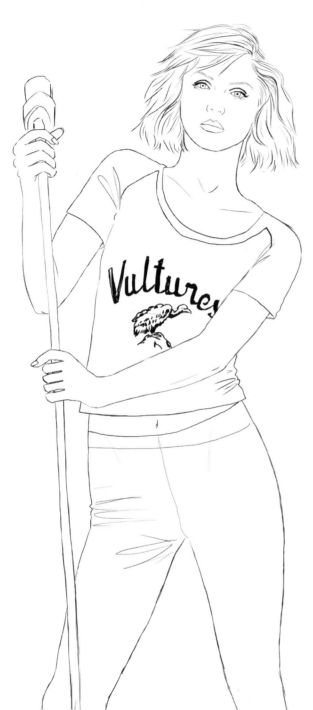

ROCK GODDESS SPECIAL

Debbie Harry

If I could look like any woman in this book, it would be Debbie Harry circa 1980 (although she looks fantastic these days too!).

The former *Playboy* Bunny is best known for being the lead singer of Blondie, the band that pioneered the American new-wave music scene.

Best Moments:
"One Way or Another," 1979
"Rapture," 1981
"Picture This," 1978
"In the Flesh," 1976

Stevie Nicks

Stevie Nicks is best known for her work with American rock group Fleetwood Mac, but her solo career more than stands up for itself too.

Best Moments:
"Landslide," 1975 (FM)
"Edge of Seventeen," 1982 (solo)
"Rhiannon," 1976 (FM)
"Big Love," 1987 (FM)
"Rooms on Fire," 1989 (solo)

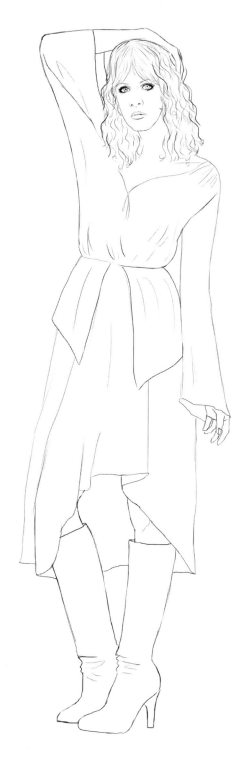

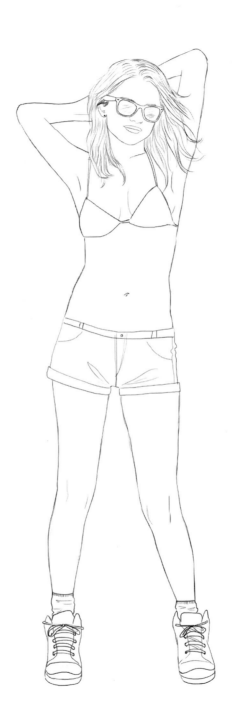

SELENA GOMEZ

Another of the ex-Disney pop princesses who has gone on to have her own fame (and we have a lot of them in this book!), Selena Gomez is sweet and driven to succeed. Growing up poor, she began acting after being inspired by her young mother, and quickly found her way onto such shows as *Hannah Montana* before starring in her own show, *Wizards of Waverly Place*. Since then she has swung back and forth between focusing on the pop-star side of her career and being an actress, while being linked romantically first to a fellow Disney star—one of the Jonas Brothers—and then to Justin Bieber.

Recently, Selena set aside her Disney roots more definitively by starring in the film *Spring Breakers*, which, unsurprisingly, is about college-age girls on spring break, and so far, has proved to be the most adult role of her career. It's going to be very interesting to see where she goes next!

Selina scores

/10

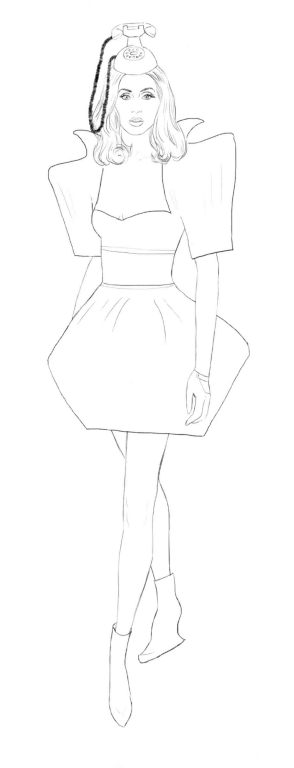

LADY GAGA

Lady Gaga has oodles of stage presence, mostly dictated by the oodles of weird costumes she comes up with. There can't be a dull moment with her around. However fantastic she may look, there is a line where fans are unlikely to incorporate strips of bacon into their everyday style. Nevertheless, as a walking art piece or modern icon, no one can come close to this Lady. And we haven't even gotten to her music and her fantastic voice, which is as powerful as she is wacky …

Quick game: What is the nearest item to your left? Staple a hundred of them together and you have yourself your very own Gaga-style dress! Nothing is beyond the realm of possibility, which is why she is just so fun to follow, and always seems to make headlines.

Sketch your dress here

I give Lady Gaga

10

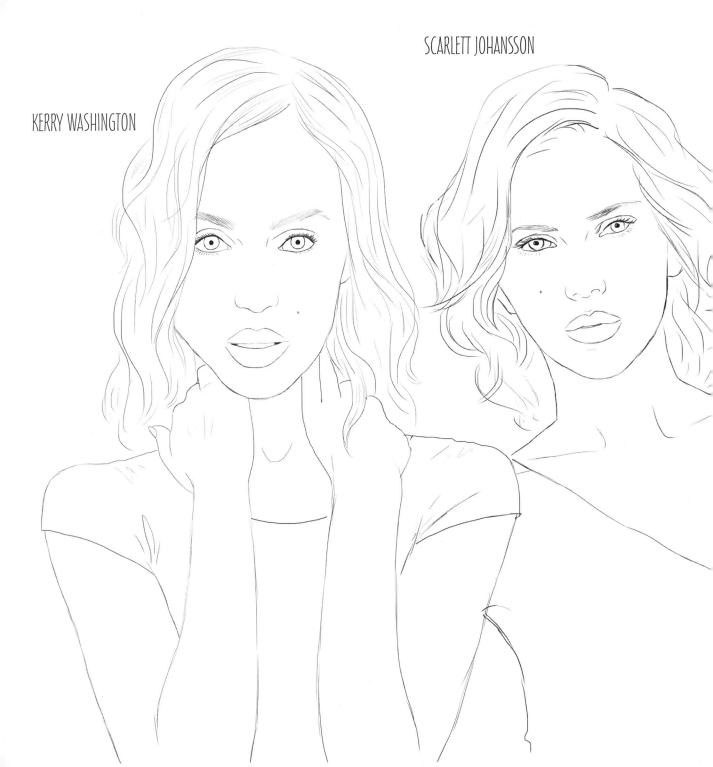

KERRY WASHINGTON

SCARLETT JOHANSSON

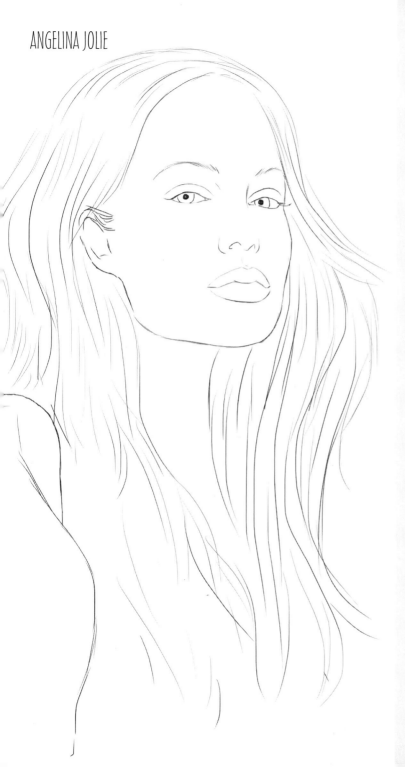

ANGELINA JOLIE

I WANT HER LIPS!

Every so often, a young starlet comes along with something on her face that really stands out ... No, not her nose, I'm talking about big, juicy lips. The type of lips you could use as a pillow. So many women try and fake the full-lipped look (and end up looking like a fish in a wig), but these women need no help in the mouth department whatsoever. They don't even need lip liner, for crying out loud!

But instead of crying "IT'S NOT FAIR!" and booking yourself in with the nearest trout-pout doctor, just accept that some ladies have luscious lips and some don't.

The women here may have lips to die for, but they're probably lacking in some other department ... okay, so they're not lacking in anything, I'm just trying to make my little lips feel less inadequate here, okay?

I give these ladies
a lip-smacking

10

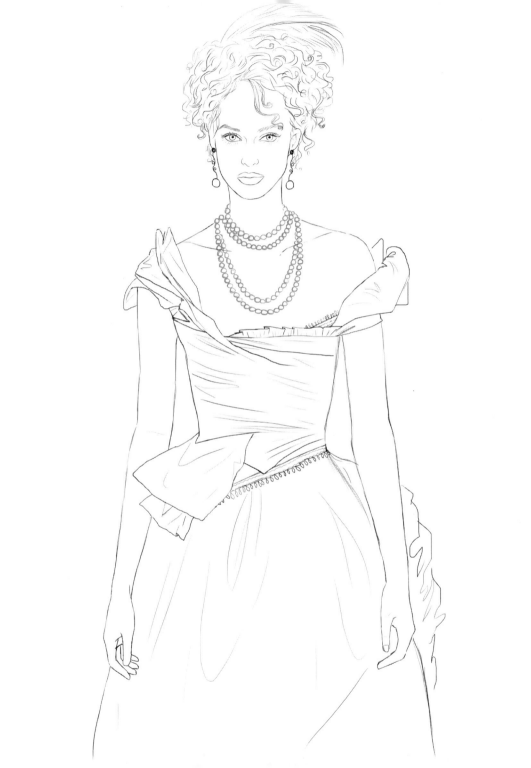

KEIRA KNIGHTLEY

Keira Knightley is spoiled positively rotten when it comes to dressing up. If she's not looking elegant on red carpets, she's wearing the most exquisite gowns in illustrious films.

Anna Karenina is one of those films.

In it, Keira (who plays a water-eyed harlot) gets to drink tea and read, while other people dress her in layer upon layer of richly colored satin.

The story is set in a vodka-fueled 19th-century Russia, where Anna and Vronsky share looks and lingering glances before falling in love during what we can only describe in modern-day language as a "dance-off." The problem is that she is married to a very grumpy Jude Law, who does not take kindly to his wife running off with someone who has a better mustache than him.

Things I learned whilst watching *Anna Karenina*:

(1) It IS possible to look chic when it is really cold outside. Rather than waking up and putting on all your clothes, try furry hats and stoles instead.

(2) Speed dating also existed in 19th-century Russia, albeit with alphabet building blocks.

(3) If you enjoy 2 hour, 9 minute-long perfume commercials, you'll love *Anna Karenina*.

I give Keira Knightley an exquisite 10

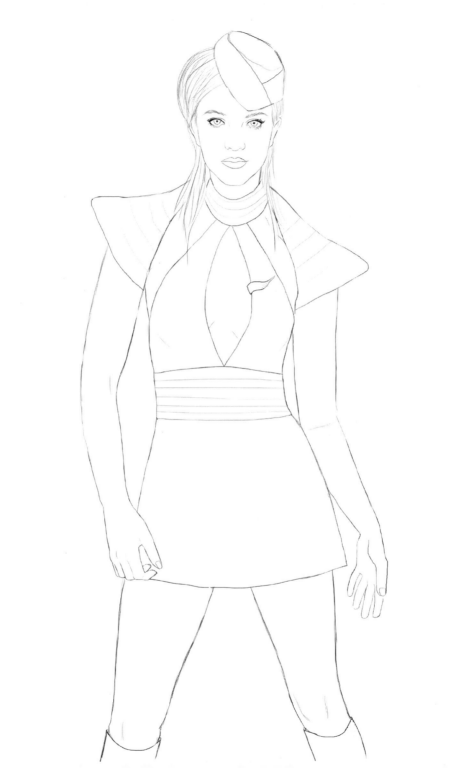

BRITNEY SPEARS

Even after all these years
It's still okay to love Britney Spears
and even after all the tears
And her famous run-in with hair shears
She's still like music to the ears
Performing to applause and cheers

When "Toxic" comes on the radio
There's just something you should know:
Your dignity away you'll throw
And sing along like you're at the show
Its catchy riff will grow and grow
It will get in your head and never go

OH NO!

Oops! I scored Britney

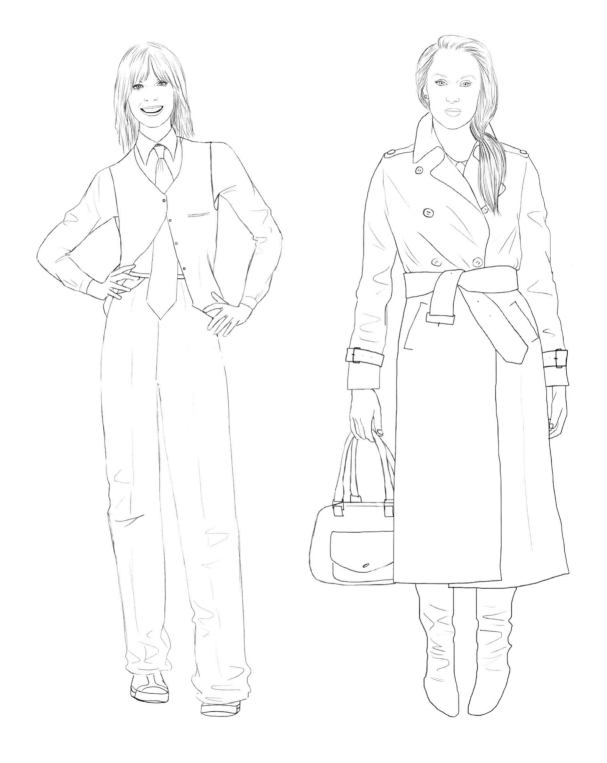

'70s SPECIAL

DIANE KEATON
Annie Hall, 1977

Diane /10

Previously known for her role in *The Godfather* and *The Godfather: Part II*, Diane Keaton showed her true potential as an ad-libbing comedy actress with impeccable timing in Woody Allen's *Annie Hall*.

Annie Hall is a romantic comedy revolving around Alvy Singer (Woody Allen) and Annie Hall (Diane Keaton). Like many Woody Allen films, it is set against both New York City and Allen's neuroses.

Annie Hall is a charming, laid-back, and slightly ditsy character, but with an impeccable sense of style. When the couple first meet, Annie Hall is all about "the boyfriend look" with boyfriend chinos, boyfriend shirt and tie, and maybe a girlfriend's boyfriend waistcoat. The truly iconic look has stood the test of time, and has been emulated by Meg Ryan in *You've Got Mail*, among many others.

MERYL STREEP
Kramer vs. Kramer, 1979

Meryl /10

Kramer vs. Kramer is a film that makes me sob even more than *The Notebook* does. If you have yet to see this film and don't enjoy crying in public, WATCH IT ALONE ... with many, many tissues.

Meryl Streep plays a smartly dressed mother in typical late '70s style, feminine blouses with knee-length skirts, slouchy boots, and long raincoats. Streep began her acting career shortly before *Kramer vs. Kramer* and has since become one of the world's best-loved actresses.

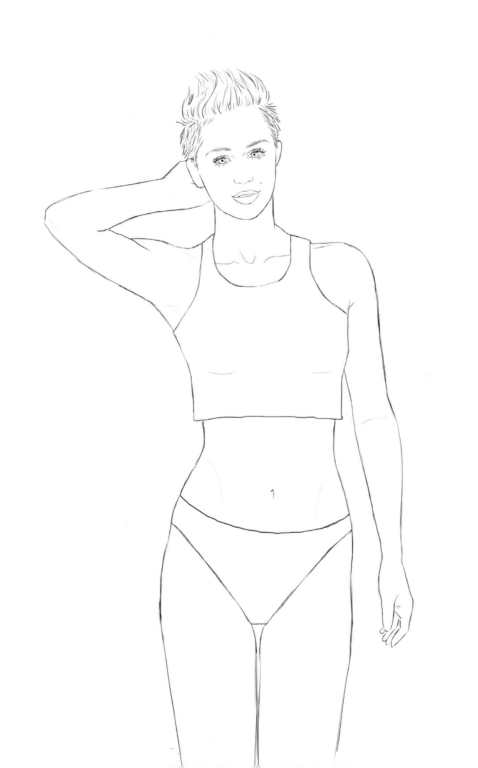

MILEY CYRUS

Despite Miley Cyrus's win at the 2013 MTV Europe Music Awards, her brilliantly shot video for "Wrecking Ball," or her equally brilliant music, she remains just as well known for her twerking exploits and revealing ensembles as she is a musician.

Beginning her fame as child pop star Hannah Montana, Miley (a nickname short for "smiley") has broken away from her cutesy Disney image and is concentrating on a more independent music career. She is quickly establishing herself as a wild force to be reckoned with, quite rightly realizing that, in an industry full of young pop starlets, she needs to stand out. And she does ... by a mile.

After growing up portraying the perfect pop star, it's understandable that she might wish to sever her ties with Miss Montana and her dad's achy breaky heart. She is young, and like all young people, she'll probably do or wear things that will make herself cringe in a few years to come, but c'mon, who hasn't!?

I score Miley a super-smiley /10

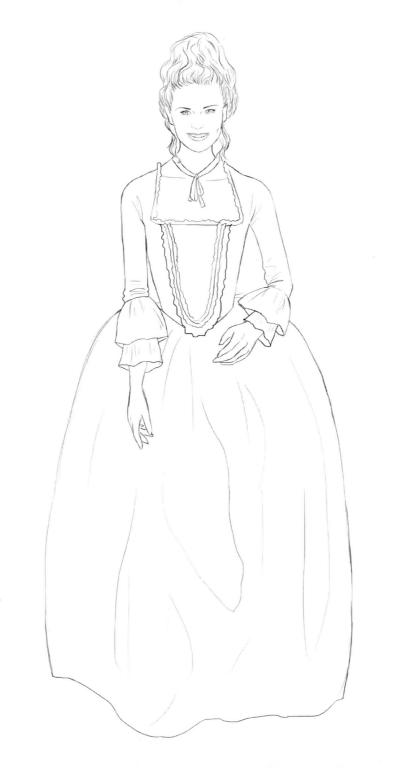

KIRSTEN DUNST

I am pretty certain that Sofia Coppola's brilliantly decadent film *Marie Antoinett*e started the worldwide trend for pugs and colored macarons.

If you haven't yet seen the film, with its romantic storyline and indie soundtrack, think of it as *The Hills* set during the French Revolution (and think of *Les Misérables* as *Jersey Shore* if we're doing the whole comparison thing).

With her adorable dimples, Kirsten Dunst portrayed Marie Antoinette as delightful and charming. Fond of colored cakes and champagne, she brought clapping back and had a bit of ooh-la-la with Jamie Dornan. Marie Antoinette was obviously very popular with the people around her—but not so much with the malnourished French commoners who didn't have so much as a petit four between them.

The Oscar-winning costumes by Milena Canonero really are about as opulent as you can get, with pastel colors, bows, ribbons, and more corsets than you can shake an éclair at!

Fantastique!

I give Kirsten a fancy French 10

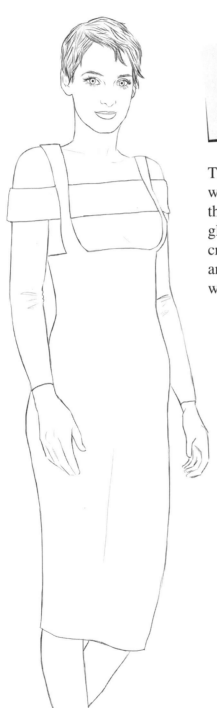

'90s SPECIAL

The 1990s seem like so long ago. When we weren't mastering yo-yo tricks, learning the theme to *The Fresh Prince of Bel Air*, and gliding along on our scooters, we were girl-crushing over the the new faces of TV, fashion, and film. The haircuts, the platforms, the high waists, and … the scarlet swimsuits!

WINONA RYDER

Best '90s Moments:
Reality Bites
Mermaids
Edward Scissorhands
Dracula
Girl, Interrupted
Little Women
Celebrity

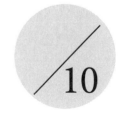

10

SHERILYN FENN

Best '90s Moment:
As supersultry Audrey Horne in
David Lynch TV drama
Twin Peaks

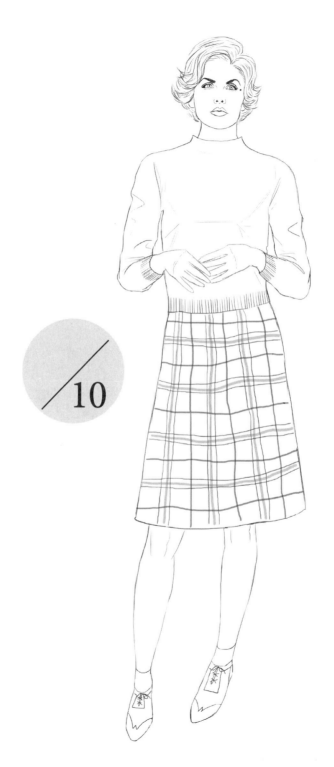

10

NAOMI CAMPBELL

Best '90s Moments:
George Michael "Freedom '90" video
Falling with grace during Vivienne Westwood's catwalk show

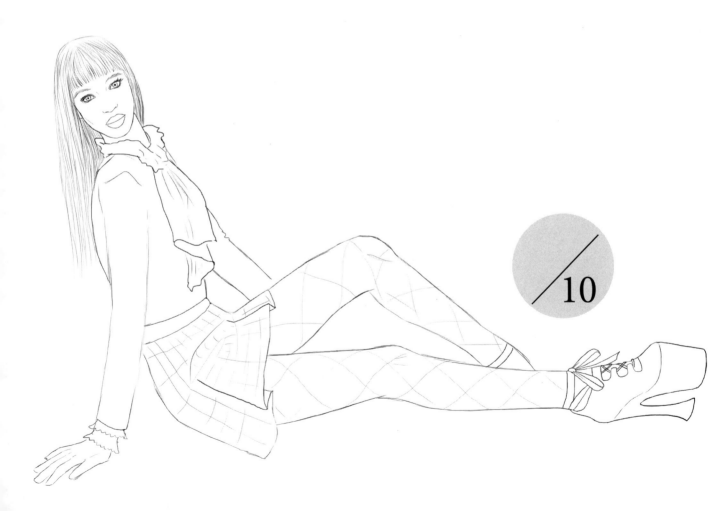

10

PAMELA ANDERSON

Best '90s Moments:

Baywatch
Home Improvement
Barb Wire

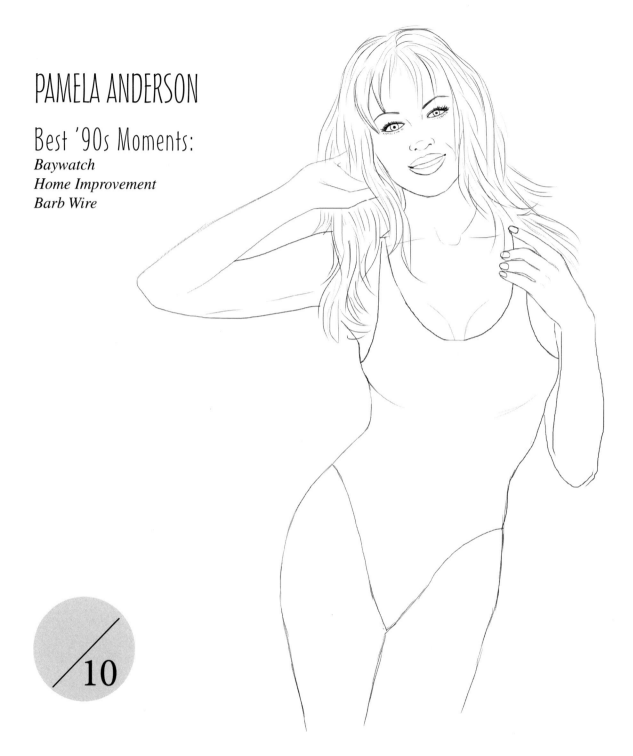

10

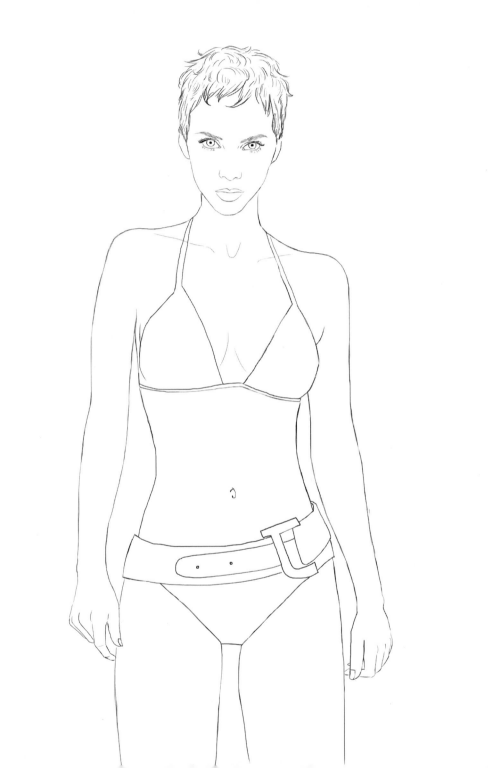

HALLE BERRY

The year was 2002, the bikini was orange, and the body was Halle Berry.

In *Die Another Day*, Halle Berry had women everywhere throwing out their one pieces and buying bikinis ... with BELTS, and the bigger the belt the better!

"However did we manage to keep our bikini bottoms up before 2002?" I can hear you thinking.

Well, bikini belts are like the Internet—you don't know how you managed without it, but somehow you just ... did.

Halle gets a berry good /10

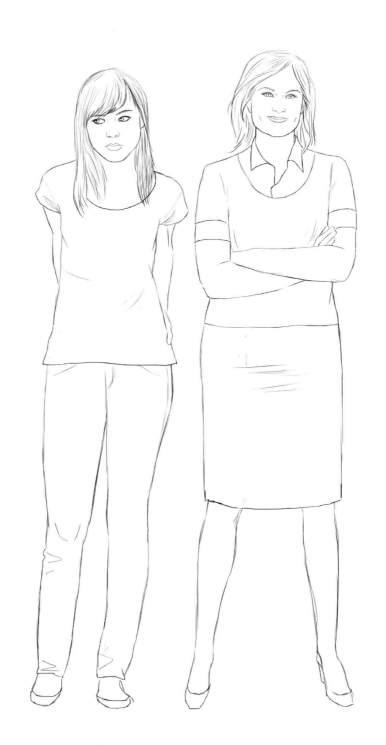

AMY POEHLER & AUBREY PLAZA

If any TV show makes me want to have a BFF to share my wine and good times with, *Parks and Recreation* is it ... and the BFF is Leslie Knope (played by Amy Poehler).

Leslie Knope is the enthusiastic mid-level member of the Parks and Recreation department of Pawnee, Indiana, and April Ludgate (played by Aubrey Plaza) begins as a lethargic young intern in the same department and later takes on more responsibility, but with the same deadpan approach. Together, they are pure comedy joy in one of my favorite shows in recent years. If you haven't seen *Parks and Recreation*, do check it out.

If you worked for the Pawnee Parks Department, who would be your BFF, Leslie or April?

Leslie ☐ April ☐

I give Amy Poehler and Aubrey Plaza

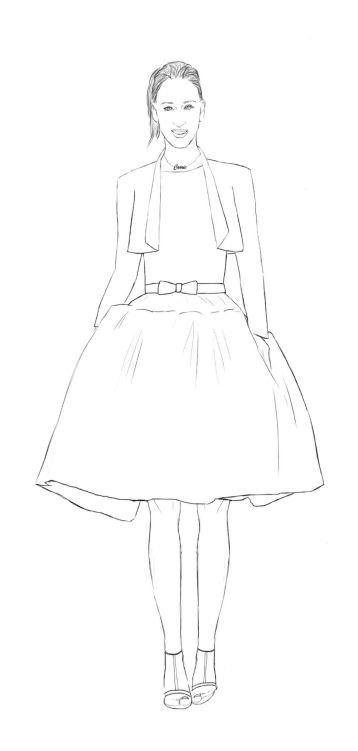

SARAH JESSICA PARKER

So I was sitting in my Manolo Blahniks* working on my MacBook, trying to channel a Carrie Bradshaw column, and I couldn't help but wonder: "Can you write a page of unanswered questions and still get any kind of point across?"

Carrie Bradshaw, the lead character in *Sex and the City*, was a newspaper columnist who seemed clueless about life, adulthood, and relationships—but she looked FANTASTIC as she wondered and pondered her way through it.

Sex and the City (both book and show) tells the story of four female friends, each one with her own set of baggage and hang-ups, and each with her own style. Time after time I would tick my way through a "Which Member of *Sex and the City* Are You Most Like?" magazine quiz, only to be mortified that I wasn't Carrie (I still think I'm most like Carrie by the way, all the quizzes were wrong).

Women worldwide lapped up the show season after season. Its honesty was reassuring and sometimes empowering, and its wardrobe department, created by Patricia Field, was outstanding.

I have depicted Sarah Jessica Parker opposite, as Carrie Bradshaw, wearing the pink Oscar de la Renta gown given to her by "The Russian."

SJP scores /10

* I'm not really wearing Manolo Blahniks, I'm actually wearing a pair of gray socks. They are inside out and there is a hole in each one where my red chipped toenail polish is on display. I just took a photograph of them.

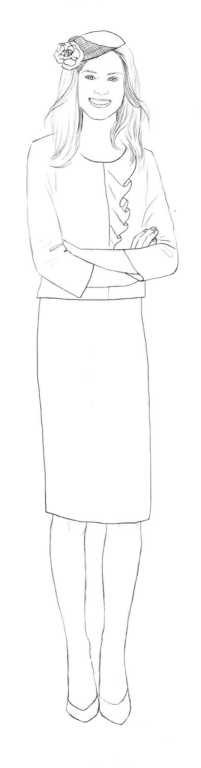

KATE MIDDLETON

...or, of course, Her Royal Highness the Duchess of Cambridge, as we should now call her. The whole world seems to absolutely love the often serenely smiling Duchess, and since her engagement to Prince William, events in her life have frequently brought everything to a standstill—millions of us tuned in to watch her wedding and the announcement of the birth of Prince George. And with that wedding she married into a family of incredible hat enthusiasts. Whether it's the odd contraption Princess Beatrice wore for Kate's wedding, or the succession of rather less flashy round hats and matching pastel suits the Queen wears to her numerous appearances, the Royal Family's women display a parade of interesting headgear.

Of course Royal fashion is usually much more traditional: the Queen has her winning formula and quite possibly a suit of similar style with matching hat in every single shade known to mankind. Meanwhile Kate is a patron of many labels, picking stylish yet sensible and flattering clothes. She makes it look so easy that her style has been endlessly imitated, and as I write, shops are probably stocking up on the next Kate trend.

I give Princess Kate a royal

10

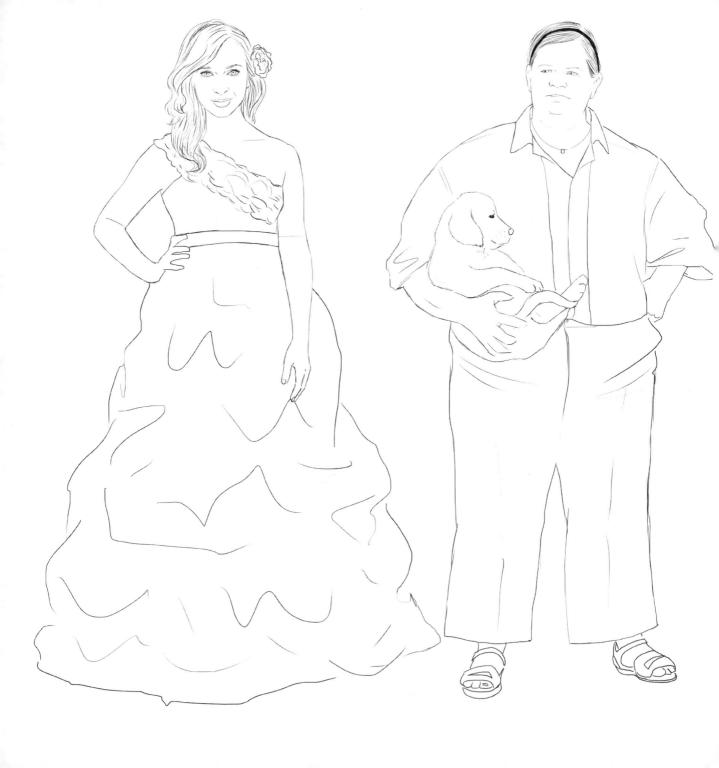

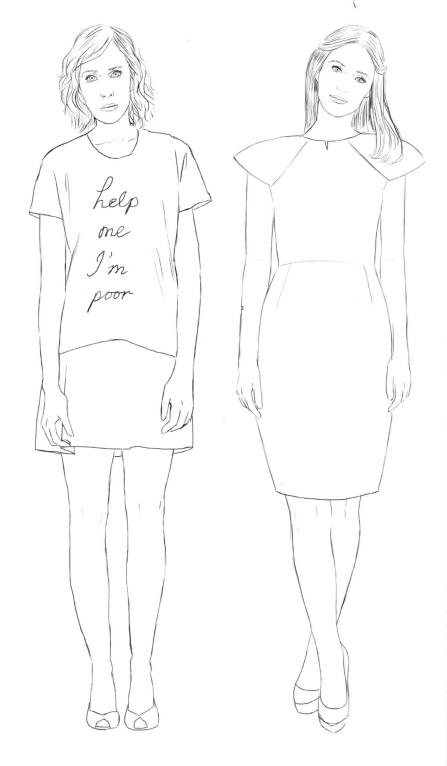

BRIDESMAIDS

Bridesmaids is the 2011 film directed by Paul Feig, following the lives of a bride-to-be and her friends as they prepare for the big day.

Starring (from left to right) Maya Rudolph, Melissa McCarthy, Kirsten Wiig, and Rose Byrne, it is undoubtedly one of the funniest films I have seen, with one cringe-worthy incident after another, each one resonating with me and audience members the world over in some way.

If you haven't seen this film yet, watch it with your girlfriends (that is, if you don't mind them seeing you literally rolling on the floor laughing).

I give the
Bridesmaids
a side-splitting

/10

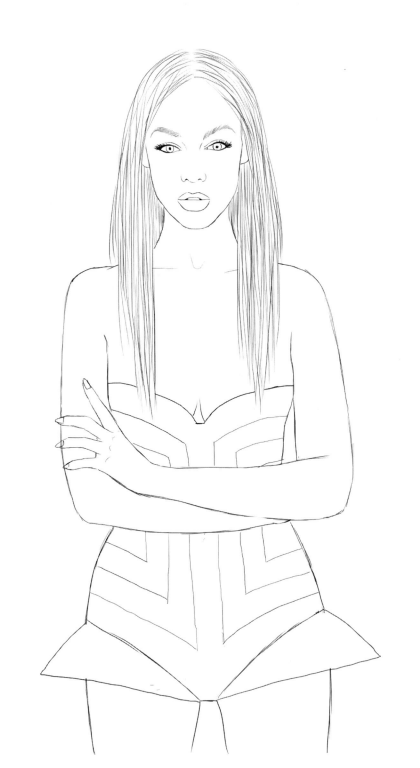

TYRA BANKS

I don't know about you, but I LOVE modeling competitions
(I also love singing competitions, baking competitions, and any
other competition that makes me cry while watching TV).

Whenever I hear Tyra say the words "I'm sorry, but you are no
longer in the running to be America's Next Top Model," I am
utterly heartbroken ... but then I realize that (A) I never entered
the competition because, (B) I'm not American, (C) I'm too old
to enter the competition even if I were American, (D) my legs
are at least 12 inches too short, (E) I have wonky "British teeth,"
and (F) I hate having my photograph taken. But other than that
I'm sure I could be in the running to be America's Next Top
Model! Hell yeah!

I adore seeing unconfident, average-looking girls eventually
strutting their stuff, realizing how amazing they are, becoming
powerful and confident, and learning to embrace what they
previously regarded as their faults.

I also adore how Tyra Banks always looks so "fierce."

I give Tyra a fierce

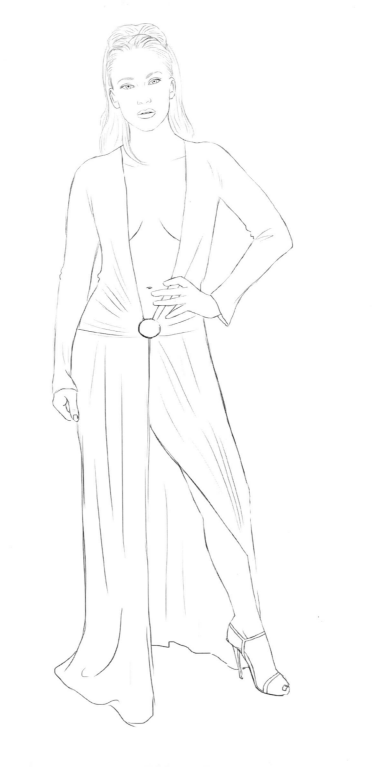

JENNIFER LOPEZ

In 2000, Jennifer Lopez wore a dazzling green Versace dress with a neckline that plunged and plunged and then plunged a bit more. She quickly became "Jenny with the Frock."

That year, Puff Diddy Whatsisname tried desperately to outshine her in his white suit that was probably made from recycled super-yachts. But he failed, miserably.

JLo's dress was sheer with a tropical print. The neckline went all the way past Jen's belly button and the split in the front of the floor-length gown went all the way up to meet it. Jen looked sensational and was most definitely the talk of the party (not that I was there or anything, I'm just guessing here, I never get invited anywhere).

Jennifer Lopez was not only responsible for showing us that plunging necklines make headlines, she also put fear into boyfriends and husbands everywhere, as the question "Does my butt look big in this?" now had two possible answers!

I give Jen a bootylicious 10

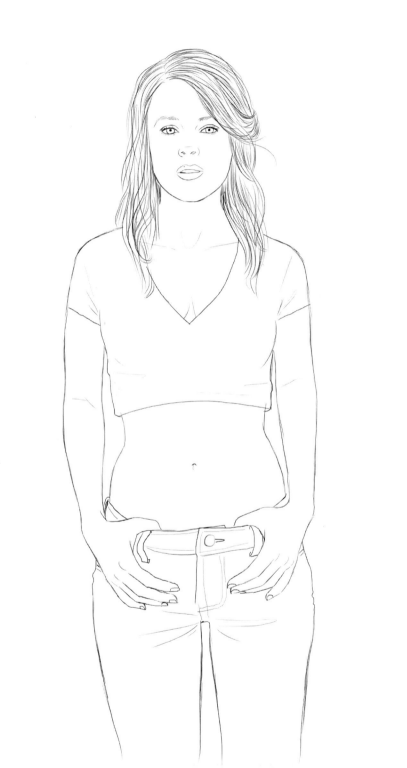

LINDSAY LOHAN

As you have probably gathered by now, I am far from perfect. I make mistakes just like everyone else, sometimes huge ones too. Sometimes I even make them in public, but I just pick myself up and continue as if nothing happened. Even with all of her errors splashed all over the front pages, Lindsay has the fighting spirit to do this too!

Having modeled and acted in TV commercials from the age of three, Lindsay Lohan shot to fame at the very young age of twelve, starring alongside herself in *The Parent Trap*. With her red hair, freckles, and cheeky charisma, audiences loved her.

She went on to star in *Freaky Friday*, *Herbie: Fully Loaded*, the absolutely brilliant *Mean Girls*, and *Confessions of a Teenage Drama Queen*. Once she made the transition from playing sassy teens, Lindsay was picked to play screen icon Elizabeth Taylor in TV drama *Liz and Dick*. Lindsay looked stunning as the raven-haired goddess.

Lindsay scores

10

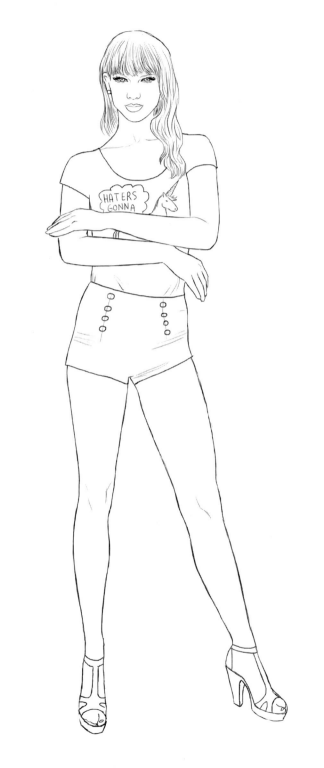

TAYLOR SWIFT

What I love about Taylor Swift
Is the thing that gets some people miffed
She dates some boys and does collect
Their information for a song project

In doing this she often caters
To Internet douchebags and they're called "haterz"
But haterz are always gonna hate
So Taylor just goes on another date

I give Taylor the best score ever, ever, ever

10

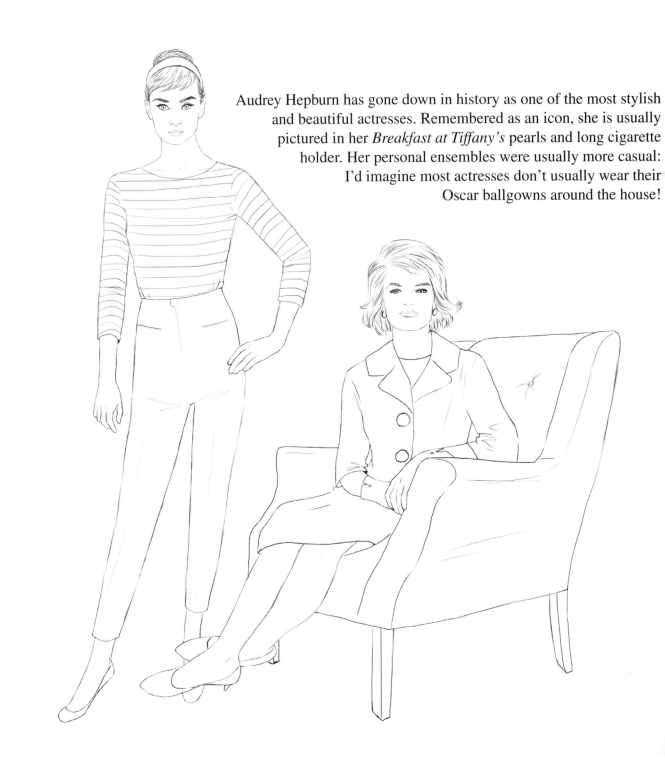

Audrey Hepburn has gone down in history as one of the most stylish and beautiful actresses. Remembered as an icon, she is usually pictured in her *Breakfast at Tiffany's* pearls and long cigarette holder. Her personal ensembles were usually more casual: I'd imagine most actresses don't usually wear their Oscar ballgowns around the house!

Twiggy made her name as a model in the '60s for being stick-thin (if you were assuming the name was completely coincidental and nothing to do with her weight, you're wrong—but points for thinking outside the box!) and for having the biggest eyes ever to sit on a human face, an effect she achieved by layering on fake eyelashes and mascara until she must have had trouble opening her eyes. It worked, and she made being an awkward teenager attractive. She's still involved in fashion today, although without the sultry expression that made her famous.

ICONS SPECIAL

A trendsetting First Lady, before she became known as "Jackie O," Jackie Kennedy had a huge impact on fashion. After her husband's death, she continued to be an icon, switching to more casual styles. She popularized several looks, from big sunglasses and turtlenecks to the wool suit and pillbox hat combination she was wearing when JFK was assassinated. Her fashion choice took a grisly turn when she refused to take the suit off, and wore it for the swearing-in of Lyndon B. Johnson, still soaked in her husband's blood. Intense.

CAREY MULLIGAN

Carey Mulligan is quickly becoming a costume-drama favorite, and no drama has more costumes than a Baz Luhrmann film. Appearing as the beautiful and stylish Daisy in his *Great Gatsby* adaptation, Carey Mulligan was the picture of 1920s flapper fashion. The actress often sports a cute pixie cut or other short style, following a disastrous run-in with peroxide for one of her earlier roles. Since then she has proved you don't need flowing hair to be adorable. In *The Great Gatsby*, her bob, with its elegant curls at the front, defines her classy look.

Bedecked in millions of dollars' worth of real diamonds for some scenes, Mulligan's dresses for the film were specially designed by Prada—again with no expense spared—as were 40 of the dresses worn by mere extras in the background of the party scenes. Carey elegantly poses throughout the film in dresses made from lace or seemingly created out of petals, as well as typical 1920s shifts and demure headscarves.

It's not hard to love Carey, a sweet and determined actress … Although it is easy to be jealous of anyone who gets to star as Leo DiCaprio's love interest!

Carey scores /10

MICHELLE OBAMA

Michelle Obama makes a powerful statement with her fashionable style. Whenever she appears beside her deeply cool husband, you'd think she would have to work hard to shine, but with her colorful casual dresses or glamorous ballgowns, she leads the world in style. Literally!

Her dresses and pantsuits have a unique and sometimes quirky style: as a First Lady and one-time lawyer you might have expected her to cut a dull, if respectable, figure, but she brings color and flair to the job. And she absolutely rocked the look when she cut her hair into bangs.

Michelle scores a mighty /10

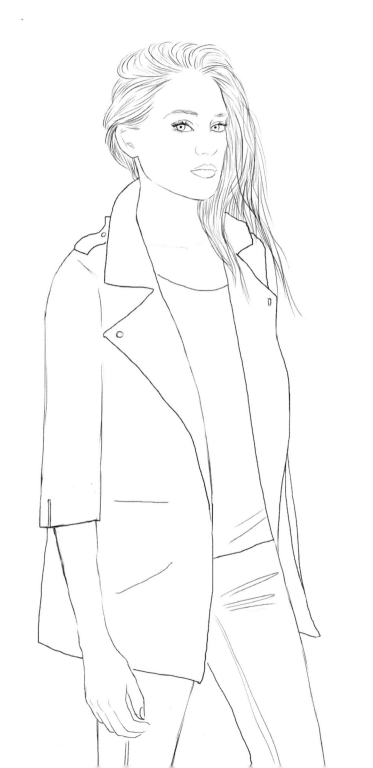

SHAILENE WOODLEY

So I recently watched the 2011 movie *The Descendants* (directed by Alexander Payne, who won the Academy Award for Best Screenplay), all in the name of work. Being a major George Clooney fan, this wasn't a huge problem, and it is an excellent and deeply moving film with an exceptional cast, part of which is Shailene Woodley.

Shailene plays Alexandra King, a sixteen-year-old whose mother is in a coma following a boating accident. Shailene plays the tough kid with a chip on her shoulder and is, I believe, the strongest, most likeable character in the film. With her long, soft hair, waiflike figure, and sad, emotive eyes, Shailene Woodley adds a certain vulnerability that I think others could not.

Shailene first showed up on the scene with her role as a moody teen in *The Secret Life of an American Teenager*, and she is the female lead in both *The Fault in Our Stars* and the planned *Divergent* trilogy.

Shailene scores

/10

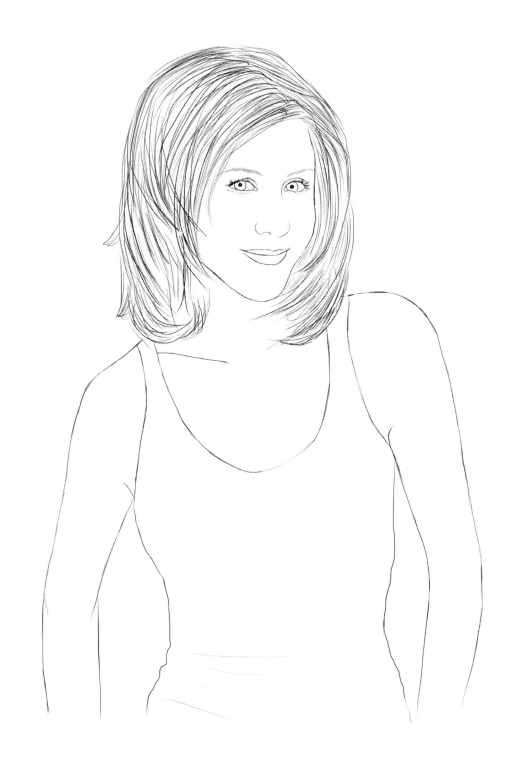

JENNIFER ANISTON

Gorgeous Jennifer Aniston came to our attention in 1994 as Rachel Green on *Friends*. Rachel was a spoiled rich girl, determined to be an independent woman with a job, a huge apartment, a circle of like-minded friends, a glamorous wardrobe, and a HAIRCUT TO BEAT ALL HAIRCUTS!

Yes, when Jennifer Aniston's hair first appeared on our screens nearly 20 years ago, women in the thousands were walking the streets of this fine planet of ours, sporting what actually resembled a grown-out mullet, dubbed the "Rachel Cut."

If you want to re-create this classic haircut:

(1) Ask yourself why.
(2) Warn your friends and family.
(3) Take the diagram below to your hairdresser (who is probably too young to remember the "Rachel Cut").
(4) Do not hold me or Jennifer Aniston responsible for the results.

Cut your hair into graduating lengths, like so, and then ...

I give Jen a super-layered

/ 10

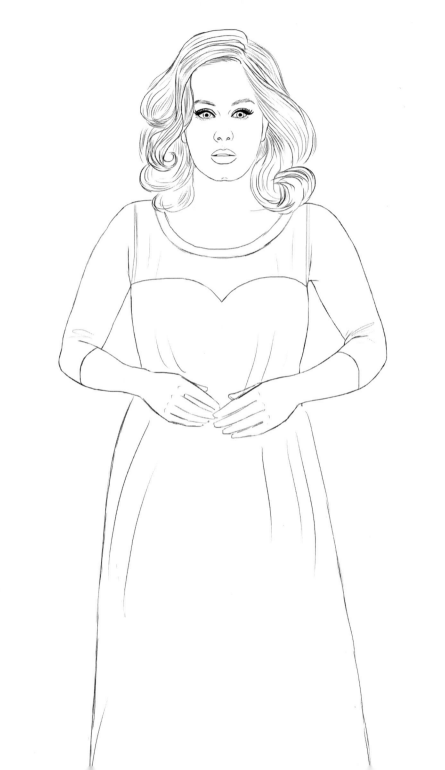

ADELE

The voice! No wait, the hair … No, it has to be the voice …
Man, it's hard to pick what is more fabulous about this beautiful singer.
No one's hair should have that much volume and curl, but hers does!
She looks like she has stepped out of another era with her retro beehives and smoky eyeshadow. It's easy to forget how young she is, appearing on the scene when she was just 19. What would you like to be famous for before you're even 20?

Adele can be as stormy as her lyrics. She's made her feelings known by giving the finger to the camera on live TV when her Brit Awards acceptance speech was cut short. She's also stood strong on her weight, claiming that she is happy as she is and won't lose it unless it gets in the way of her life—a reassuring change of pace from many stars who fear they'll be cast out into the cold for gaining a single pound!

And now we should sit quietly and worry about just how much trouble would be caused if she actually worked out how to set fire to the rain …

Adele gets a fabulous /10

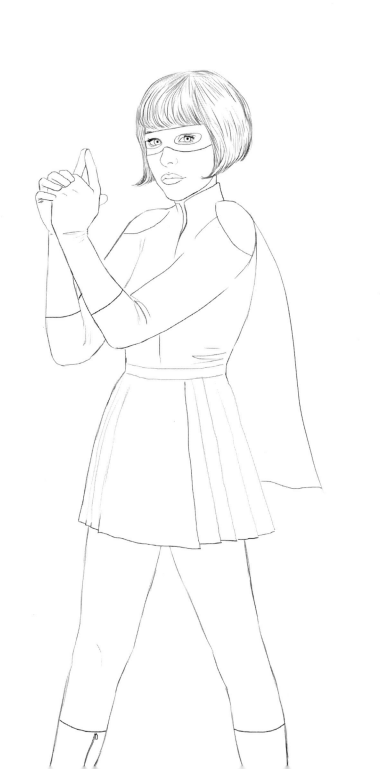

CHLOË GRACE MORETZ

At the young age of 16, Chloë Grace Moretz is fast becoming one of the world's best-loved actresses.

She's hilarious as the sassy, wisecracking little sister alongside Joseph Gordon-Levitt in (500) Days of Summer, super-cute in Diary of a Wimpy Kid, super-vulnerable in Hick, and super-kick-ass hero in ... er ... Kick-Ass (and Kick-Ass 2).

Chloë seems to have made a name for herself within the horror genre too, with Let Me In, The Eye, Room Six, The Amityville Horror, and scary schoolgirl Carrie all under her belt!

Chloë gets a kick-ass

10

LISA BONET

An open letter to Lisa Bonet:

Dear Lisa,

Like many women, I would have given my right (and left) arm to be you in 1984. While everyone else was parading around in white stilettos and ra-ra skirts, you stepped away from the crowd, found a massively popular TV show to be on, and used it flaunt your experimental, bohemian style. You were the coolest thing on the planet, hands down.

On behalf of fashionable women everywhere, I would like to say "thank you." Without you (and your incredible talent for spotting trends, decades before anyone else does) ...

• We would only be able to buy brogues in men's sizes.
• The only people wearing headscarves would be old grannies.
• MC Hammer wouldn't have had any trousers on in his "U Can't Touch This" video. Eww!
• People would still be running away in fear of girls with side-cuts.

Thank you, Lisa, from the botttom of my fashion-loving heart.

Love,

Mel x

I give Lisa a super-cool /10

RACHEL McADAMS

The Notebook has to be the sappiest sob-fest of a film in the history of filmmaking. Anyone who can sit through this film without sniveling their way through a box of Kleenex needs to go straight to the emergency room to check if they actually have a heart.

Rachel McAdams plays Ally to Ryan Gosling's Noah, a couple of feisty young lovers who become separated and heartbroken due to parental intervention and that pesky romance-stopper they call "war."

Noah writes Ally a letter every day for a whole year, but she never gets them ... you can see where this is going, can't you?

Anyway, before I start welling up again, I chose to feature Rachel McAdams in *The Notebook* because of her dainty 1940s tea dresses, headscarves, and hats and gloves. It also gave me another opportunity to gaze at Ryan Gosling and claim it as "work."

If you were trying to make Baby Goose say YOU are some kind of animal, what would it be?

..

If Ryan's a 10, Rachel's a

LUCY LIU

Lucy Liu is gorgeous and elegant, an artist-humanitarian-actress who reads books, and an award-winning film villain. Yes, we love her more because she just seems to kick ass wherever she goes! As one of her first major roles on our screens she was the antagonistic Ling Woo in the legal comedy/romance *Ally McBeal*, delivering deadpan lines as the complete opposite to the sweet, if flighty, Ally. Later we got to enjoy her as a head-severing yakuza boss in *Kill Bill*—just another day at the office for her! After her experience as one of Charlie's Angels I'm starting to worry that she really does know how to kick butt and so I'd better write nice things about her!

Lately Lucy has been starring as Dr. Watson in *Elementary*, making history as one of the first women to play Watson as well as one of the first actresses of Asian descent to be given main character billing in a primetime American show. And she's doing a service to girls everywhere by playing a dramatic role without pesky romance writers geting between the main characters and messing things up! "Joan Watson," as the character has been renamed, has a very girl-next-door style, notably wearing adorable printed dresses or T-shirts, with fresh-faced makeup—and she still looks perfect!

Lucy gets an elementary

10

TAVI GEVINSON

Tavi Gevinson started writing her fashion blog titled *Style Rookie* at the tender age of 12. She posted photographs of her tiny self in crazy outfits and she wrote about current trends, as well as how some of her favorite films and music had shaped her sense of fashion.

Tavi is known for being herself, inspiring other girls her age to embrace what they love. She has spoken at many high-profile conventions but with a sense of modesty, not claiming to be a teenage genius or prophet, but just being into stuff, like any other teenage girl.

Rookie is an online magazine founded by Tavi in 2011, which has since sparked two yearbooks. It is an online portal for teenage girls, as well as being Tavi's (and other contributors') creative outlet. Whether you're a teenage girl, boy, or just someone who wants a different opinion, give it a read.

Tavi and the next girl are far too cool to be marked out of 10

"ONE CHILD,
ONE TEACHER,
ONE BOOK,
AND ONE PEN
CAN CHANGE THE
WORLD"

Malala Yousafzai, 2013

MALALA YOUSAFZAI

Malala's story is one that inspires absolute horror: a teenager being shot by the Taliban for campaigning for education for girls. However, it ends in hope, as Malala survived and is now a hugely influential public speaker, with plans to head into politics to try to address the problems that led to her assassination attempt.

We love Malala not just because she's brave and a survivor, but because she was fighting hard before she was shot, and has come out of it fighting harder for what she believes in. It's inspirational for every girl, and she's the sort of girl we should all really want to be.

ABOUT MEL ELLIOTT

Rather than write some boring blurb about myself, I got my Facebook friends to ask me questions:

What started you on the whole coloring book thing?
I met a printer and fell in love. I was thinking of stuff he could print and ended up considering what I'd like to buy that I couldn't ... and a Kate Moss coloring book was the answer! This was in 2008, and it wasn't until 2009–10 that I considered it an actual job.

Have you ever used the British Embassy?
Yes. I got stuck in Milan once with no passport or money and had to survive on some stolen breadsticks and a bottle of brandy. The British Embassy was fantastic!

Have you ever met Shakin' Stevens?
No, but I did see him in concert in Blackpool once.

Have you ever kissed a celebrity?
While in Blackpool I bought a satin cushion with Shakin' Stevens's face on it. I used to kiss that cushion … a lot.

Who is your ultimate girl/boy crush from the '80s and '90s?
'80s—Vanessa Paradis when I first witnessed "Joe le taxi" and Michael J. Fox (once I was over my Shaky obsession). '90s—Kate Moss and Noel Gallagher.

Who is your favorite member of One Direction?
Harry. I saw them live in Barcelona this year (on my own) with an open mind, but Harry stood out for me.

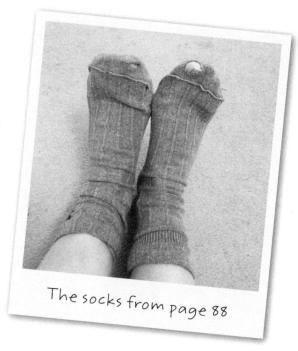

The socks from page 88

If you could take five things onto a desert island, what would they be?
A coloring book, my pencil case (which has an eraser and sharpener in it too), a kettle, some teabags, and some matches.

Do you ever eat cold baked beans straight out of the can?
ABSOLUTELY NOT! I shudder at the thought!

If you were DJing, what three tracks would you play to fill the dance floor?
"I Feel Love" by Donna Summer, "Harder, Better, Faster, Stronger" by Daft Punk, and "Dancing with Myself" by Generation X.

What was the first ever *Color Me Good* image?
It was a drawing of Kate Moss with her shoulder straps falling down. It's still one of my favorites and I have it pinned to my studio wall.

Please check out Mel's other book:
Color Me Swoon
as well as her full range of coloring books and other gifts, at
www.ilovemel.me

Twitter: **@mellyelliott**